BEVERLEY
in
50
BUILDINGS

LORNA JANE HARVEY & PHIL DEARDEN

AMBERLEY

First published 2019

Amberley Publishing, The Hill, Stroud
Gloucestershire GL5 4EP

www.amberley-books.com

Copyright © Lorna Jane Harvey & Phil Dearden, 2019

The right of Lorna Jane Harvey & Phil Dearden to be identified as the Authors of this work has been asserted in accordance with the Copyrights, Designs and Patents Act 1988.

Map contains Ordnance Survey data © Crown copyright and database right [2019]

All rights reserved. No part of this book may be reprinted or reproduced or utilised in any form or by any electronic, mechanical or other means, now known or hereafter invented, including photocopying and recording, or in any information storage or retrieval system, without the permission in writing from the Publishers.

British Library Cataloguing in Publication Data.
A catalogue record for this book is available from the British Library.

ISBN 978 1 4456 9051 3 (print)
ISBN 978 1 4456 9052 0 (ebook)

Typesetting by Aura Technology and Software Services, India.
Printed in Great Britain.

Contents

Map 4

Key 6

Introduction 7

The 50 Buildings 8

Bibliography 94

Acknowledgements 95

About the Authors 96

BEVERLEY

Key

1. Beverley Minster
2. St Mary's Church
3. Beckside Buildings
4. Old Friary
5. The Monks Walk
6. Guildhall
7. North Bar
8. St Mary's Court
9. Sun Inn
10. Rose and Crown
11. Green Dragon
12. Black Mill
13. Former Police Station
14. White Horse Inn
15. Beverley Arms Hotel
16. King's Head Hotel and Pub
17. Pipe and Glass Public House on Dalton Estate
18. Newbegin House
19. Beverley Racecourse and Grandstand
20. The Hall
21. Warton's Almshouses
22. Beverley Market Cross
23. Tiger Inn
24. Ann Routh's Hospital
25. Norwood House, St Mary's School for Girls, and Beverley High School
26. Walkergate House
27. The Beaver
28. Nos 4-6-8 North Bar Without
29. Beverley Golf Club, Anti-Mill
30. Beverley Beck Lock and Keeper's cottage
31. County House of Corrections
32. The Sessions House
33. Gateway to Beverley Gasworks
34. Woolpack Inn
35. Memorial Hall
36. Beverley Railway Station
37. Grovehill Shipyard
38. Westwood Hospital
39. The Former Corn Exchange
40. St John's Ambulance Brigade Headquarters
41. Urinal to the Sessions House
42. Cross Street County Hall
43. Toll Gavel Church
44. Roman Catholic Church of St John of Beverley
45. Grammar School
46. Public Library
47. Post Office
48. East Riding Theatre
49. The Treasure House
50. Former Hodgson's Tannery and Flemingate

Introduction

Beverley's rich architecture is beautiful in many parts, and although it may not have the size or the grandeur of some of England's larger cities, its charm and historical significance merits much praise. The town was likely built on the foundations of early Celtic settlements that predated the minster by several hundred years. In the eighth century, Beverley grew quickly as a religious centre before it was raided by the Danes and then ravished by plague. Textile manufacture and continued ecclesiastical interest revived the town and carried the economy through the Dissolution of the Monasteries, the Civil War, and much more. Beverley was arguably one of the most important industrial centres in northern England in medieval times.

Although Beverley's history spans over more than 1,300 years, many of the market town's buildings were constructed in Georgian and Victoria times on medieval foundations. The buildings hold histories from a time when the Industrial Revolution was well underway and Captain Cook toured the world in search of new lands. I've chosen a wide variety of buildings for this book. Some are famous, others less so, but all have their place in shaping or representing Beverley's rich history. Most of the buildings have survived many wars and revolutions, and herein lies their tales…

The 50 Buildings

1. Beverley Minster (No. 38 Highgate)

Officially the Minster Church of St John, the Beverley Minster is a Gothic masterpiece and a Grade I listed building that survived dissolution in the sixteenth century. In the eighth century, Bishop St John of Hexham, York and Beverley founded the monastery in the Deiran Wood on the grounds of a small parish church. The monastery grew into the minster. It was nearly demolished by the Danes in the ninth century, but was rebuilt within a few decades.

After St John of Beverley was canonised in the eleventh century, the church drew many pilgrims who believed St John had performed miracles. They contributed greatly to Beverley's development as a merchant town.

A fire in 1188 demolished much of the cruciform-shaped minster as well as the rest of the town, but the minster was rebuilt with limestone and leaded roofs. Henry III

Beverley Minster is one of the largest parish churches in the country, and has near-perfect proportions.

Above left: The vaulted ceilings contain beautiful examples of Gothic art. (Thank you to the vicar and churchwardens for their assistance and photo permissions)

Above right: Restoration work continues, as it has for several centuries. Scaffolding can be seen on the right-hand side of this photo.

offered forty oaks from Sherwood Forest to help rebuilding work in the thirteenth century, after the central tower collapsed because of heightening works. Two storms damaged the minster in 1863, and a pinnacle was struck down by lighting. A roof fire also began in the nineteenth century but was quickly extinguished.

The towers on the west front, built in the fifteenth century, are in the Perpendicular style and inspired the construction of the west towers of Westminster Abbey. Underground passages were said to lead to two former abbeys several miles away (in Holderness to the south and Watton to the north).

A frith stool can be found in the north aisle of the minster. Also known as the 'Frid', 'Sanctuary' or 'Peace Chair', it dates from the eleventh century and is one of the last surviving examples. Murderers and other criminals used it to claim sanctuary or the protection of the church. Several crosses stood a mile from the minster to mark the threshold of partial sanctuary. Criminals could remain in the sanctuary for thirty days and try to gain pardon.

Despite centuries of reconstruction in different styles, the continuous vaulting from one end of the building to the other offers a harmonious feeling to the whole.

2. St Mary's Church (North Bar Within)

St Mary's Church, originally a Norman church, dates from 1120. It started as a chapelry to the minster until 1325, when it was made a distinct vicarage. The nave was built in the thirteenth century. It was progressively added to through to the sixteenth century, bringing a rich architectural story with Norman features and Perpendicular style. Rich carvings and panels show forty English kings from the seventh century onwards.

The old Yorkshire expression 'better to be at a bear-baiting than singing at mass' likely comes from St Mary's tower collapse during a 1513 Sunday service. Many were crushed and fifty-five people killed. The tower appears to have fallen towards the west. After years of continual building and adding to the structure, it was no longer sound. It took four years to rebuild the tower and the nave, which had also been seriously damaged. In 1676, much damage was again done to the church when it was struck by lightning. It is difficult to imagine the mayhem that must have taken place during the continual construction, collapse, and renovation when you stand under the beautiful ceilings' decorative constellations or in the peaceful crypt.

Before street lighting was implemented, a lantern hung in the tower to guide travellers to Beverley on dark nights, as roads were bad, cloud cover frequent,

Below and opposite: St Mary's Church. (Thank you Reverend Becky Lumley for photo permissions and helpful information)

and road signs non-existent. St Mary's tower can be seen from far off, making it a useful guide for travellers.

St Michael's Chapel inside the church also has a stunning vaulted roof. A stone carving of a rabbit with a pilgrim's staff and scrip shows itself to the careful observer. This is believed to have been the inspiration for the White Rabbit from *Alice's Adventures in Wonderland*.

The Grade I listed building is primarily made of magnesian limestone and has a lead roof. The running costs of the church is around £2,000 per week, and the church is in the midst of a £5.6 million campaign to restore the stonework, which has badly deteriorated.

3. Beckside Buildings

The Beverley Beck is born from springs in the wolds, and spills into the tidal River Hull. This water access has been treasured for over 800 years. Great quantities of clay were added to the beck's muddy edges so that houses could be built, and constant silt dredging allowed boats to navigate. This brought the riches of trading with the sea and the world to Beverley. Beckside, as the area is known, was a busy

commercial and industrial area from at least the twelfth century. Timber buildings flanked the beck on the south side (Barleyholme) and north (North Beckside).

Tolls (called pavage) were collected for use of the beck, which contributed to maintenance of the watercourse and paving the nearby roads. The beck's head was culverted in the nineteenth century, and the bank sides were shored-up. A lock was built in 1803 since the Beverley and Barmston Drain resulted in the lowering of the level of the beck.

Tanning, wood and textile working were trades that used a lot of water. The raw materials for those trades could be easily imported on the beck, and the processed goods exported at a profit. Shops and market gardens thrived in the area, along with mills, tanneries and shipbuilding. Watermills and brick makers with smoky kilns were also along the beck. By the twentieth century, seeds, coal, molasses and hides were primarily shipped. Overhead cranes hooked bales of hides from the barges, and children tried to get their fingers into barrels of molasses for a taste.

A seed mill was one of the beck's last major industries, along with Hodgson's tannery, which had a fleet of seventeen barges. Although many of the old buildings have been demolished, a few remain. Among a handful of others, original portions of Barker's Mills are Grade II listed, fronting the beck.

Over the centuries, the Beckside buildings and methods of industry were refined and the muddy streets paved, but the beck remained profitable for trade until the 1970s. Now Beverley's only waterside residential area feels calm and fairly luxurious, a contrast from what it once was.

Below left: Beckside buildings.

Below right: The *Syntan* is a motor vessel moored near the head of the Beck (in the background). It's the last of Hodgson's barges, and was rescued by the Beverley Barge Preservation Society.

Original portions of Barker's Mill can be seen on the left side of the photo. The early nineteenth-century, three-storey brick building has a segmental rusticated stone doorway.

4. Old Friary (Friars Lane)

The Old Friary is a medieval structure founded by the Dominicans (followers of St Dominic) in 1210 or possibly earlier. The Black Friars of Beverley, as they were known due to their black clothes, originally occupied a larger area that included a church. They were mostly teachers. The friars built their first friary out of wood on the land that was given to them by the Archbishop of York.

As money allowed, extensions and other buildings were added, particularly in the fourteenth century. The Dissolution of the Monasteries in the sixteenth century saw the friars expelled and most of the buildings demolished, except for the guesthouse, which had not been used for religious purposes. The friary was mentioned in Chaucer's *Canterbury Tales*.

The guesthouse was sold in 1544 and changed hands many times over the next centuries. In 1887 the buildings were used as a clergy house. The construction of the railway destroyed some of the remains of the friary as well. Armstrong Patents purchased the property in the 1960s and requested to demolish the remaining buildings to expand his nearby factory, but the demolition request was refused by the town.

The buildings are brick and stone, and many of the internal walls are framed.

Above left, right and below: The row of disheveled buildings presents a mix of architecture and materials that hint at the journey these grounds have endured over the centuries.

The Old Friary is a Grade II* set of listed buildings and one of around ten surviving friaries in England. It's owned by the East Riding of Yorkshire Council. The Beverley Friary Preservation Trust works alongside the council to maintain the buildings. The site operates as a youth hostel, who rent the buildings. A fifteenth-century hammer-beam roof, sixteenth-century tiled floors, and a seventeenth-century limestone fireplace can be found inside the crooked buildings. The archway in the front gardens leans even more precariously than the rest of the buildings.

5. The Monks Walk (No. 19 Highgate)

The Monks Walk pub, previously called the George and Dragon Inn, dates back around 800 years. Parts of the building were erected in 1260, but the main construction of the inn is dated to 1671. The earlier construction was part of the Warton family house. The two-storey red-brick building has remains of a half-timbered interior, and is an example of the Artisan Mannerist style. It's a Grade II* listed building.

Clay pipe-makers worked out of the George and Dragon yard at the back of the building in the nineteenth and twentieth centuries, which is now a beer garden with a great view on the minster.

Sometimes known just as the George, or the Old George and Dragon, the pub has many features that have barely changed over the centuries, although live sports can now be viewed there.

The *Hull Daily Mail* reported in May 1995 that during renovations parts of medieval cottages had been discovered inside the structure and dated to approximately 1420, and roughly cut tree trunks were also found in the roof timbers.

A fire in 2000 could have destroyed nearly a millennia of history, but the damage was fairly minor and the pub reopened in 2001. The Mairs and the Blizzards ran the pub for significant periods in its history. The passage that runs between Highgate and Eastgate is still referred to as 'Blizzard's Passage'.

6. Guildhall (Register Square)

The Beverley Guildhall has been central to Beverley's governing for over 500 years. Originally a merchant's large house, massive timber walls survive from the fourteenth century when it would have been more of a medieval great hall.

The governors of Beverley acquired the building in 1501 from Edward Mynskyp, and the deeds to this 1320 house still exist. Swine Moor (then known as Tunge) was sold to purchase the Guildhall. Before 1501, the wealthy guilds used a rented building in Saturday Market Place. The rule of the governors shifted to municipal councillor functions with time. While the plague lingered throughout much of England in the sixteenth and seventeenth century, Beverley was incorporated, allowing for a more independent and structured government. In 1573, Beverley became a corporation with a mayor and twelve governors. The Hanse House, or Guildhall, functioned as town hall, sessions house, court and registrar's office for over three centuries.

The Guildhall was in dire need of maintenance by the eighteenth century. Despite repairs in 1730, the walls in some rooms had to be lined with matting to keep the damp out. In 1762, more thorough repairs took place. Architect William Middleton renovated parts of the interior, including the courtroom, which has a white and blue covered plaster ceiling in the rococo style. In 1835, the Guildhall was refronted. A sandstone Doric portico was added by Charles Mountain Jr. The fluted columns are surmounted by a triangular pediment.

The mayor gave dinners to the governors at least twice a year, along with entertaining guests such as royalty and the archbishop. Elaborate pewter and silver from the eighteenth century are on display. Some of Beverley-born artist Fred Elwell's paintings are also displayed at the Guildhall. 'Mayor's Minstrels' from 1423 can be seen in the museum as well. They are some of the oldest in the country.

The Guildhall is a Grade I listed building, and was used for the quarter sessions until 1810, and as a magistrates' court until 1991. The Guildhall is no longer in use for governing the town, but now houses the Beverley Community Museum.

Above: The 1832 pre-Victorian Greek Revival-style façade was inspired by the Greek Temple of Apollo, Delos.

Right: The elaborate stucco ceiling in the Georgian courtroom is by notable Swiss stuccoist Giuseppe Cortese, and the furniture is original to 1762 as well, including Chippendale chairs.

7. North Bar (No. 8 North Bar Without)

The Beverley North Bar is the last surviving brick town gate in England. It was built for a little under £100 in 1409 by the town council. It took over 100,000 local bricks to build it. At the time Beverley was a wealthy town, thanks in large part to the wool, leather and brick industries. North Bar replaced a stone bar or gatehouse, which had likely been built around the twelfth century along with a dyke. In the fifteenth and sixteenth centuries there were five brick gates in Beverley, which were all demolished in the eighteenth and nineteenth centuries, except for the North Bar.

Traffic is limited to single file, and controlled by traffic lights. The North Bar was nearly demolished several times, most recently when double-decker buses couldn't fit through the arch, but in 1934 Beverley's double-deckers' roof lines were modified to fit. Other large vehicles unfortunately get stuck regularly and damage the structure.

Although the gatehouse gave some protection to Beverley, its main purpose was to collect tolls. Henry V collected more than £20 from North Bar passage tolls in 1420. During the English Civil War, the North Bar was locked at night with

Below and opposite: A time traveller would find things mostly unchanged from the fifteenth century at North Bar in Beverley.

thick oak doors and a portcullis; however, it failed to protect the town during the Pilgrimage of Grace and the Civil War.

Two side passages for foot traffic have been cut through on either side of the main opening. During the construction of one of the pedestrian passageways next to the main opening of the bar in 1867, a thick stone wall was uncovered that is thought to have been part of the earlier gateway.

Designated a Grade I listed building, the two-storey gatehouse was renovated in the seventeenth century and several times since (most recently in 1996). Above the arch is a carved stone coat of arms (the Warton's) on the north side, three shields on the south side, recessed windows and a crenelated parapet.

8. St Mary's Court, formerly Armstrong Garage (Nos 49 and 51 North Bar Within)

Gordon Armstrong, born in 1885, came to Beverley in 1907 and set up a garage in a set of small buildings at the intersection of Tiger Lane and North Bar Within. The buildings he chose were already an estimated 500 years old at the time, although he likely chose them for the convenience of the courtyard behind the buildings and the warehouse-like structure of some of the buildings rather than for their antiquity. The set of buildings consisted of three shops and twelve cottages at the time.

St Mary's Court, as the set of buildings are now called, are Grade II* listed buildings dating from the fifteenth century. These houses are Beverley's earliest surviving

Left: This small and ancient set of buildings housed one of England's great innovators and entrepreneurs.

Below: Armstrong factory workers around 1940. (East Riding Archives)

non-religious buildings and are representative of what many of the buildings in the town would have looked like in the medieval era. The two-storey buildings retain their timber framing with rendered stone infill, and parts overhang Tiger Lane with curved braces, giving the structure an ancient and precarious appearance.

Gordon Armstrong's *East Riding Garage and Engineering Works* quickly prospered. After building motorbikes, cycle-cars and a car called the Gordon, Armstrong created an innovative patent shock absorber as well as the independent front suspension (IFS) that made the business famous. He had customers such as Ford and Aston Martin.

As the business grew, he eventually expanded into Crosskill's old premises on Eastgate. He expanded again in 1964 and bought a 10-acre site on the Swinemoor Lane Industrial Estate. Gordon Armstrong passed away in 1969, and the Unilever Corporation purchased Armstrong's company in 1974.

In the long history of St Mary's Court, Armstrong's enterprise was perhaps only a short one, but it has brought this set of buildings to the public's attention and likely contributed to its protection. St Mary's Court is now a shopping arcade.

9. Sun Inn (No. 1 Flemingate)

The Sun Inn is the oldest pub still in existence in Beverley, depending on how the Monk's Walk is dated. It was built sometime before 1540, possibly even in the 1400s. It was also known as the Tabard in its early days and had a thatched roof. The first-floor joists are laid on an edge rather than flat, which was current in the seventeenth century.

The timber frame has been rendered and it seems that the original building was not demolished, but rather renovated and altered over the course of several centuries. It is a two-storey Grade II listed building with half-timber and colour-washed brick, and some herringbone brick infill. The interior was significantly altered during extensive alterations in 1905, and it doesn't retain many original interior features. During these renovations, the former coal house was transformed into a kitchen at the back of the building.

In 1851, thirteen 'brutes' were recorded as being dissatisfied with their dinner at the Sun Inn, and complained. They devoured the next meal given to them to make amends. In 1872, police were called to the public house because drunken men were fighting outside. The police found musicians and dancing in the front room, along with over sixty people and (not for the first time) prostitutes. The landlord, George Wiles, was charged at the Guildhall for keeping a disorderly house and fined a little over £3. He agreed to pay the fine and did not have any explanation to give the judge.

The Sun Inn is across from the minster. Its name was briefly changed to the Tap and Spile Public House, before being returned to the Sun Inn in 2000. The renovations have kept up with modern requirements to the detriment of some of its history, but the pub is known to have good beer and food, and frequent live music.

Above and left: The Sun Inn. (Thank you Richard Price and Lee Tomlinson for photo permissions)

10. Rose and Crown (North Bar Without)

The Rose and Crown was first recorded in the Elizabethan year of 1574 as The Bull. At the time the last of the Tudor monarchs, Elizabeth I, ruled England and Shakespeare began writing.

A saddler named Stephen Smailes and his wife Margaret were granted the ownership of the freehold property. An adjacent horse field likely made this property of particular interest to a saddler. Whether the saddler's building was eventually transformed into a pub, or when a new building was erected is not noted, but it's likely that the Bull functioned as a mix of public house, saddler's hotel and stables. Ponies were known to be sold on the grounds, and a butcher had a small shop at the front of the buildings in the late nineteenth century.

The first records of the property being called the Rose and Crown as a public house were in 1800. The building had many guest rooms and stables, and frequently served in conjunction with the racecourse and hunters from the Westwood. In the eighteenth century, landlord Robert Norris was also a clerk for the racecourse, and he brought much of the registry business to the Rose and Crown.

The Grade II listed building is a two- and three-storey structure with attics, and in half-timbered style on a rendered-brick ground floor. Carved bargeboards frame the gables and the wood posts below the balcony. It gives the impression of a Tudor building, but this aspect was only brought to it in 1931 when extensive

Above, right and overleaf: The Rose and Crown. (Thank you to the Rose and Crown's managing director, Mark Cross, for photo permissions)

renovations were requested by the new tenant, Fred Leach. The main entrance was also then moved from York Road to North Bar Without. Architects Darley & Co. wrote to the Beverley Corporation in 1930 describing the project. It was to be significantly altered, but the building's height would remain unchanged.

The pub is situated at an important crossroads, just outside the North Bar. It has had ongoing maintenance, but remains much as it would have in 1931.

11. Green Dragon (No. 51 Saturday Market)

The Green Dragon is accessed through a narrow alley to the left of the building. A courtyard with outdoor seating opens up at the end of the long alley. Inside, live music can often be heard on weekends. Like many buildings in the core of Beverley, it's difficult to date the construction as houses were often built over parts of older buildings, using some of the ancient foundations. Normally, a major renovation

Above left and below: The Green Dragon.

Above right: A wide wooden bay window enables passers-by to glimpse frothing beers and plentiful warm food.

leads to more understanding of the building's roots, but no such extensive works have been undertaken at the Green Dragon in recent years. It is recorded that the Grade II listed building was altered in the early twentieth century. The two-storey white-painted stucco building with mock Tudor-style timber façade sits lower than its neighbours, and has an ornamental iron bracket and a hanging sign at the first-floor level. The building is long and narrow with fairly low ceilings on the ground level. There are signs of timber framing in the walls, possibly suggesting an even older construction date.

The Green Dragon was called the Malt House in 1746, but likely dates back to the seventeenth century. It was renamed the Green Dragon in 1765. The original entrance was probably on Lairgate and may have also been called the Green Dragon and Black Swan for a time.

12. Black Mill (Westwood)

New or High Mill (as it was first known) was built in 1655 on the 400-acre Westwood common pastures. It was erected by the Mill Corporation, which was founded in the sixteenth century. The structure was likely wooden and may stand over a Bronze Age burial mound, not far from an Iron Age square burial mound. Five mills are known to have once worked on the Westwood, but only two still stand. The Black Mill is conveniently located on raised ground, which favours ideal winds for the mill. In 1803, it was rebuilt and was then known as Far Mill or Baitson's/Bateson's Mill.

Below and opposite: The uneven land in the foreground of the photo may be the mounds of an ancient burial site.

After the Pasture Act of 1836, the Mill Corporation tried to keep control of the mills, but in 1861 a militia's revolt led to the freemen lighting fire to the mill. Although their actions seem detrimental to their cause, they saw it as a way to free themselves from fees, which they thought unfair on what had become common pastures. Although it was eventually rebuilt, the working gear was dismantled by the pasture masters (elected by the freemen of Beverley) when the lease expired in 1868.

By the early twentieth century, Beverley's cricket ground occupied the area near the Black Mill until the Norwood sports grounds were opened. The ownership of the land (where the mill stands, and the surrounding Westwood) was not settled until 1978. Courts decided that it's owned by the council (currently the East Riding of Yorkshire Council). Now locally known as Black Mill, the former corn mill is a Grade II listed building and only the stump of the structure stands. It's a tarred-brick five-storey structure with a crenelated top. The windows and doors are blocked, but the dark structure watches over nearly all of the Westwood. There is a powerful feeling about the place, perhaps in part due to the 4,000-year-old graves that may be below the mill's feet.

13. Former Police Station (Register Square)

Beverley Gaol occupied the rendered building adjacent to the Guildhall from the late seventeenth century until 1810 when the House Of Correction was built to replace it. The building likely dates to 1663, as a stone in the wall on the exterior of the buildings has the date inscribed. Extensive alterations to the original building in order to make it usable as a prison removed most of the building's original character and aspect. It is basically square in shape and two storeys high. The pale building has a wide twentieth-century door and is a Grade II listed building, which forms part of a group of buildings in Register Square (including the Guildhall). Another, older gaol occupied a building on Toll Gavel from around 1540 to the late seventeenth century.

The infamous highway thief and murderer Dick Turpin was likely held in this building in 1738, when it would have been called the Beverley House of Correction. He was transferred to York where he received the death penalty.

Parts of the building appear to have also served as a charity school in the eighteenth century, and graffiti on some of the walls likely came from the students.

Once the prisoners had been transferred to the new house of corrections, the building eventually served as a police station following years of the police office being located in the Guildhall next door.

The East Riding Constabulary merged with the borough police in the twentieth century, and the headquarters were located next to the Sessions House. The police station in Register Square was maintained as a divisional station until 1983 when

Above: It would be easy to miss the building that adjoins the elegant Guildhall in Register Square. However, the unassuming building has a firm place in Beverley's history.

Right: This window may have been a former prisoner's cell.

the building was deemed structurally unsound. The divisional station in Register Square was moved to the headquarters on New Walk, where it remains.

Parts of the building were demolished in 1985 and the rest repaired. The building is now used for offices.

14. White Horse Inn, aka 'Nellie's Pub' (No. 22 Hengate)

The pub was first recorded in 1666 when it was a coaching inn, and retains many of its original features. Some sources suggest there was a pub on the site of the White Horse Inn from 1585. It's a Grade II* listed building, and one of the oldest pubs in Beverley. Wobbly stone and creaking wooden floors, roaring open fires and gas lights in the pub are mostly unchanged from their original days. A warren of small rooms and narrow passages adds to the cozy feeling of the place, as well as the smell of the gas lights, which wafts around the place. An old well survives at the back, unlike the stables, which were demolished.

Susannah Sokill leased the nineteen-room, tiled property from the Corporation of Beverley in 1732, which also included three thatch-covered stables. Frances Burrell ran the place in 1851, according to the census of the same year in which it was described as the White Horse brewhouse and saddlers shop.

Its bulging brick exterior walls might worry some, but add to the charm for most. It's likely that the building was timber framed in the seventeenth century, and later brick fronted, which would help explain the wall curves.

Above and opposite: The white horse over door was Richard Whiteing's (a family friend) old rocking horse. The bulging wall leans over the pavement a little precariously.

In 1927, the Collinson family purchased the White Horse from St Mary's Church (they had already been leasing it for about four decades), and one of their fourteen children was a daughter called Nellie. She helped her father in the pub from the time she was a teenager, and managed it from the time of his death in 1952 until it was sold to Samuel Smiths Old Brewery in 1976 when Nellie was nearly ninety years old. Nellie, a hunchback at the end of her life from pulling beers, refused to serve alcohol to nurses and banned women from the bar area.

Frequent candle-lit quiz nights and tasty Samuel Smith beer continue to keep the 400-year-old pub a lively place in Beverley.

15. Beverley Arms Hotel (No. 25 North Bar Within)

Exactly when the first inn stood on the grounds of the Beverley Arms Hotel is difficult to know, but the first records mentioning it date from 1686, when there was room for 182 guests and stables for 460 horses. The Blue Bell, as it was first known, accommodated the infamous highway robber Dick Turpin in 1732 before he was captured.

The property was expanded and mostly rebuilt in 1794 by William Middleton, taking over an adjoining house and becoming the Georgian building it is today. It still shows the classic Middleton design that is common in local Georgian buildings. The Blue Bell was renamed the Beverley Arms Hotel at this time. It's a three-storey building of red brick and stone dressings, and a Grade II listed building.

By the 1840s, the Beverley Arms Hotel was a posting house or staging inn where horses could be rented or changed, until the railway reached Beverley. It was also a brewhouse and had its own billiard room.

In 1966, when a major renovation was underway, the hotel had fifteen guest rooms. As the renovation progressed, a sealed-off sixteenth room was found at the front of the building. It was integrated into the hotel with the mystery unsolved.

At that time, the receptionist wore an ankle bracelet and had afternoon tea with a man she called her uncle. It seems she ran away with the man. For days, travelling salesmen were asking about her whereabouts and the story made the front page of local newspapers.

Beverley Arms was long reputed to have a big wine cellar with excellent wines. The cellar was used as the air raid shelter for guests of the Beverley Arms during the Second World War.

Since the eighteenth century, the hotel was an important meeting place for businessmen, and politicians. The hotel was used for auctions, social events and sometimes political speeches from the balcony.

Major renovations in 2018 have transformed the Beverley Arms into a luxurious hotel. There are thirty-eight guest rooms and an outdoor courtyard with a beautiful view of St Mary's Church.

Above and right: The Beverley Arms Hotel has an arched doorway that makes it stand apart from the adjoining buildings. Although the interior has been altered over the last three centuries, the famous kitchen that Elwell painted has recently been restored and can be viewed complete with copper pans.

16. King's Head Hotel and Pub (No. 38 Saturday Market)

The King's Head Hotel, formerly known as the Commercial Hotel, is a Grade II listed building from the late seventeenth century, first renovated in the early nineteenth century. It's a three-storey, painted stucco building with a slate roof on the east side of the Market Place.

Its white, black and grey colouring looks almost modern among the other buildings in the square, but beers have been served here for hundreds of years. The second-floor central window is arched and centred over a small stone Greek Doric porch with two painted columns.

Two hundred years ago there were stables for sixty horses attached to the inn, and served as a posting inn. There were around twenty beds as well. The Hull Brewery Company owned the pub for many years. Centrally located, three other pubs can be seen from the King's Head. A lot of people felt that drinking beer was safer than water as it was less likely to be filthy or diseased. The King's Head often served as a meeting place where business was conducted, while the business owners' employees tended to frequent the Green Dragon across the square.

The pub has recently undergone a substantial renovation and is part of the Marston's Inn company. The rooms are above the restaurant and bar, and there are two large outdoor patios or garden bars where the horses would have been in the past.

The King's Head.

The rear access to the pub has a pleasant courtyard away from the market area's bustle.

17. Pipe and Glass Public House on Dalton Estate (No. 18 West End, South Dalton)

The Dalton estate is first recorded in the 1086 Domesday Book as a farm with a value of 40s. In 1201, Sybil of Vallines gave the Knights Hospitallers some land in South Dalton. The Crown granted the property to the Aslaby family in 1552 after the Dissolution of Monasteries in the sixteenth century.

The Hotham family purchased the land in 1680, and built the main house in the 1770s. The estate was enlarged over the following two centuries, and is approximately 200 acres. The Dalton estate is several miles outside of Beverley, yet is part of Beverley. The owners, the Hotham family, were known to also keep a house in the town on Eastgate in the eighteenth and nineteenth centuries. The estate is now managed by the Hotham Family Trust, and the grounds are well-preserved examples of eighteenth-century rococo gardens.

The Pipe and Glass.

The Pipe and Glass Pub was once the original gatehouse to Dalton Park. Parts of the building may date to the late seventeenth century, and a yew tree in the garden is more than 400 years old. It is a former coaching inn, and was purchased from the Hotham family by the Jackson family of Hull in 1950. In 1989, the pub burned and suffered extensive damage. It was restored and changed hands many times over the following decades. In 2006, it was purchased by the Mackenzie family and renovated again. The inn has five boutique garden rooms, a private dining room, a large restaurant and a traditional bar area. Herb and kitchen gardens supply some of the restaurant's needs, and two outdoor dining areas complement the Pipe and Glass, which has been awarded a Michelin star and has been featured flatteringly in several pub guides and reviews.

18. Newbegin House (No. 14-16 Newbegin House)

Newbegin House, at No. 14/16 Newbegin in Beverley is a Grade II* listed building. Its history has not always been recorded accurately as there are several houses on Newbegin that have been known as some variation of Newbegin House. The building has more of the feeling of a grand hall than the others on the street, likely because of its large size, balanced aspect and park-like gardens.

The red-brick building was erected in the late seventeenth century and consists of two storeys and an attic. It has a hipped tiled roof and three dormers

Above and right: Newbegin House.
(Thank you Mr Paul Simpson, owner of
Newbegin House, for photo permissions)

Newbegin Lane curves elegantly towards Newbegin House.

(the central dormer is more recent than the others). The doorway is, like most of the other features on the front of the building, symmetrically centred with stone steps and delicate iron hand rails. Above the front door is a nineteenth-century wood traceried fanlight window, and the whole is framed by a decorative moulded stone doorcase. An ornate staircase dated to approximately 1690 and stone-flagged flooring in the hall are some of the details that make this house particularly important and a notable heritage asset.

In 1771, the Courtney family purchased Newbegin House, as well as some buildings across the road, which were demolished to enlarge the park-like gardens. This explains why iron railings (now covered in a yew hedge) form the boundary wall along Newbegin, as it would have allowed John Courtney to have visibility on his grounds across the road. In the mid-nineteenth century, the house may have been a boarding school for young women, although there is some uncertainty as to whether it was this Newbegin House or the house at No. 10. The building is now privately owned.

19. Beverley Racecourse and Grandstand (York Road, Westwood)

In 1690, a racecourse was authorised at the picturesque Hurn on the Westwood, and by 1767 the Beverley Races were regular. Before this time, a circuit around the Black Mill called Tan Gallop was sometimes used for informal races.

The course was lined with bark waste from the town's tanning industries. Complaints of disorderly racing led to laws being passed regarding the orderly conduct of the races. Cockfights and unruly football games were often held during the races, if not nearby, within the town.

In 1752, the Jockey Club was founded, and in 1768 the first race grandstand was built for the accommodation of the people of Beverley by local architect William Middleton. The cost of the construction of the grandstand was recuperated through the sale of 330 admission tickets (which cost 3 guineas each). A second one was designed by architect A. Beaumont and built in 1887 as a commemorative grandstand next to the old building. In 1851, thanks to increasing audiences coming on the new railway from Hull, up to 6,000 spectators were present at each race. A new grandstand replaced the old ones in 1939 and 1968 and extended in 1991. A new structure may be built in the near future, but the racecourse remains unchanged in its local and national importance.

In 1914, 179 acres of the Westwood were requisitioned by the military authorities. The racecourse was part of the area requisitioned, and an aerodrome was set up in the area.

The course is a right-handed flat course of a little over a mile, and is within walking distance to the town centre. Sheep are kept inside the fences of the racecourse. It is run as a not-for-profit organisation. Continual improvements are

Beverley Racecourse.

Left: The racecourse judge box and scoreboard are housed in this small tower.

Below: The Grandstand with a crowd, 1911. (East Riding Archives).

made to the buildings and racecourse, and several events and festivals are held there each year. It is frequently named in the top fifteen racecourses in England, and ranked alongside such courses as Aintree, Ascot and Cheltenham. Nineteen race meetings are held each year between April and September.

20. The Hall, also known as Lairgate Hall (Lairgate Champney)

The Hall, or Lairgate Hall, is a Grade I listed building of exceptional interest that dates to 1700. Some of the original park-like gardens remain with magnificent mature trees and manicured gardens. The red-brick building was the Pennymans' town house and was known as Beverley Hall.

Prior to The Hall being built, the grounds belonged to the medieval hospital of St Giles', which was dissolved in 1536. It was the oldest hospital in Beverley and annexed to the St Augustine Priory in 1277. The hospital had around twenty beds and the patients were cared for by four priests.

The house built in 1700 had five bays and a large hipped roof. It was extended based on a design by York architect John Carr in 1771, and a sweeping staircase and sandstone Roman Doric portico were also added in 1780. Richly detailed mahogany doors and finely carved marble fireplaces, along with well-preserved hand-painted green Chinese wallpapers and detailed Georgian plasterwork on the ceiling of the drawing room add to the special interest of this building.

The Hall was adapted to house the East Riding of Yorkshire Council before becoming private office spaces.

The Hall.

The sandstone Roman Doric portico frames the main entrance to Lairgate Hall.

21. Warton's Almshouses (No. 104 Minster Moorgate)

Warton's Almshouses were first built in 1712 under the provisions of Michael Warton's will, dating from 1688. His brother, Sir Richard Warton, also contributed to the construction of the almshouses. Older buildings were demolished to make way for the hospital. Michael's son, Charles Warton, subsequently augmented the financial support to the almshouses and the buildings were extended for the first time. In 1774, Sir Michael Warton rebuilt and expanded the almshouses through a £1,000 bequeathment. Lord Burlington, a highly respected and powerful amateur architect, influenced the design of these almshouses, which are said to be built in plain style.

The trusteeship of the Beverley Corporation oversaw the construction and operation of the almshouses. The Warton family were important landowners in Beverley, and they also contributed financially to repairs of the minster and to the charity school. Twenty-eight poor widows were housed in these almshouses. It seems that elderly men had far fewer (if any) similar facilities in the town at the time.

Only some of these buildings still stand. The remaining set of almshouses are Grade II listed buildings. They are two-storey red-brick buildings with plain tile roofs, and overall not elaborate. Wrought-iron guard rails flank the steps.

The almshouses had two nurses who lived on site. Each widow had a small private room, received a weekly allowance, coal for heating and a new gown every two years. The allowances came from the income of Killingwoldgraves

Above and right: Warton's Almshouses.

Information plaque on the almshouses.

Farm in Bishop Burton, which was also bequeathed and held by the trustees (and eventually sold in 1918). The widows were on average in their eighties, and came from all over Yorkshire.

Parts of the buildings that were demolished in 1962 are now gardens and car parks, but the rest have been renovated and remain in use as Warton's Hospital.

22. Beverley Market Cross (Saturday Market Place)

Beverley Market Cross, sometimes known as 'Saturday Market Cross' or 'Butter Cross', is a Grade I listed building – a grading reserved for buildings of the highest significance. The Georgian edifice was designed by the architect T. Shelton and built in 1714 in Saturday Market. It was paid for primarily by Sir Michael Warton and Sir Charles Hotham (MPs for Beverley at the time). It bears the Warton, Hotham, England (Queen Anne's royal arms), France and Beverley's coats of arms. It's octagonal in shape and its floor is three steps above the ground. Eight solid stone pillars support a cupola roof and square glazed lantern. A gilded ball and a cross or weathervane crown the edifice. It was first repaired in 1769 when eight enriched urns were added over the columns, and several times since.

Prior to the Market Cross being built, a larger structure with room for a wagon to pass through and a tiled roof stood in its place, but was damaged in 1707. Before that, a simpler standing cross likely stood in its place. It would have served

Above and right: Beverley Market Cross.

The trapdoor that accesses the loft of the Market Cross can be seen in this image.

partly to define the inner boundary of the Liberty and Sanctuary of Beverley Minster, and mostly to encourage honest trading.

Saturday markets have been held here possibly since the early thirteenth century. Sovereigns were historically proclaimed at the cross. The Market Cross also served as public stocks. The last person to be stocked there was Jim Brigham in 1855 for excessive drinking.

Soldiers were allegedly hidden in Market Cross' loft for five days during the Battle of Britain. A local is said to have kept them alive by bringing them food and water at night. Maybe they were traumatised British soldiers who couldn't face another battle, or German spies (it might even have been the German spy with the ginger beard who'd been seen around Beverley around then), or perhaps this is simply a folk tale. There are, however, other tales of German spies being seen in and around Beverley during the Second World War, likely because of the nearby Royal Airforce Stations.

23. Tiger Inn (Lairgate)

The Tiger Inn was built in 1746 by Peter Thompson. It was first known as the Black Bull. It's a double-pile two-storey brick building that was refronted in 1931. The rendered façade has applied mock Tudor-style half-timbering. Vine-leaf-carved bargeboards decorate the gables.

Many of the 1931 renovations are similar in aspect to the Rose and Crown's. Architects Wheatley and Holdsworth were apparently responsible for both renovations. Prior to the refronting, it was a double-pile building. During this renovation, the stables were demolished. Two ornamental rainwater heads at the ends of the main gable add interest to the pub. The Black Bull changed hands several times in its early days, and its name was likely changed to the Tiger Inn when the other and more famous Tiger Inn (North Bar Within) closed.

The Black Bull made its name known in the press when a prostitute named Fanny Turner was found fighting with another woman in the Black Bull in 1858. The Georgian Inn had a shop attached to it as early as the 1860s, likely selling beer jugs. It's one of the most attractive pubs in Beverley, partially due to the half-timbering.

Below left and right: Flowers contrast pleasantly with the black and white pub in the glowing afternoon sunlight.

24. Ann Routh's Hospital (No. 28 Keldgate)

The Ann Routh Hospital was built in 1749 thanks to Ann Routh Moore's will of 1721. It was initially built for twelve women on the former site of an orchard, but expanded to accommodate thirty-two widows by 1810. The initial construction cost a little over £387.

The residents were given a purple woollen gown and a silver badge engraved with Ann Routh's name and date of death. The widows were to wear these every day and frequently attend church. They were fed, housed and even given pocket money. Two nurses were available for any sick residents. Each resident had their own room, a luxury many of the widows may never have experienced before.

The two-storey red-brick almshouse or hospital for elderly women and widows is a Grade II listed building and has a coloured rococo cartouche of arms that rests on an inscribed tablet that describes Ann Routh's donation. It was designed by architect James Moyser and built by Thomas Wrightson. The building is gable end to Keldgate Street, unlike the others on the street.

Like many other buildings of its time in Beverley, the building has the Firemark sign attached to it, which means that it was insured by the Sun Assurance company

The purple-clad widows who lived in the Ann Routh Hospital in the eighteenth and nineteenth centuries had probably never before lived in such comfortable conditions.

The coloured rococo cartouche of arms above an inscribed tablet that describes Ann Routh's donation.

against fire. This company, founded in 1710, had its own fire brigade, but only protected buildings that it insured.

Keldgate had more almshouses and hospitals than any other area in Beverley, probably because of land availability and proximity to the town centre. The almshouses were generally managed by the corporation or trustees, and eventually by the Beverley Consolidated Charities.

Ann Routh was a wealthy widow who had been married and widowed twice. Her first husband, Chris Moore, left her the sum of £100 a year, which she willed for the purposes of this hospital. Her second husband, Thomas Routh of Snaith, only lived for one year while they were married. Ann Routh also left funds for schools, including the Blue Coat School.

The former almshouse is now a private home.

25. Norwood House, St Mary's School for Girls, and Beverley High School (Norwood)

Norwood House was built for the attorney and three-times mayor Jonathan Midgley in 1765 on the site of his previous house. The three-storey brick Georgian house dominates the Norwood area. It had a close or gardens of

St Mary's School for Girls' first building. (Thank you to Beverley High School for photo permissions)

Norwood House, 1937. (East Riding Archives)

approximately 9 acres behind the house, laid out like a park. It was one of the richer houses in Beverley in the eighteenth century. The house is a Grade I listed building. The remarkable Norwood House has modest dimensions, a wide pediment and finely detailed edging, which contrasts pleasingly with the flanking wings' hipped roofs. A circular window in the tympanum with extended chains of husks distinguishes the façade. Two pairs of stone gate piers and wrought-iron gates from 1780 guard the front of the property. The house was purchased by the East Riding County Council at the beginning of the twentieth century.

A high school, St Mary's School for Girls, was built in similar style near the building in 1875 and is a Grade II listed building. The Gothic-style building was designed by J. B. and W. Atkinson of York on a site given by T. Crust.

In 1908, a further building was erected nearby, and the whole formed the Beverley High School for Girls. Norwood House was annexed to the high school for many years, but the Beverley High School for Girls ceased to use Norwood House in 2000. It is now a restaurant and tea rooms in which the ornate ceilings and walls can be admired. Beverley High School continues to function in several buildings alongside Norwood House, and is rated as a high performing secondary school.

26. Walkergate House, now Register Office (No. 67 Walkergate)

Walkergate House was built in 1780 when, as can be read on a plaque secured to the building, 'Beverley was becoming a fashionable town of elegant houses and imposing public buildings.' It was designed, similarly to other fashionable villas, with a five-bayed front, tiled roof and a fairly modest yet dignified wooden entrance.

The first theatre's performances in Beverley were held somewhere in Walkergate in the late eighteenth century – likely in Walkergate House. Two large rooms that now serve as ceremony rooms could easily have been used for theatrical performances.

Walkergate House and Norwood House (built about two decades earlier), have similar garden windows, gardens with flowing walkways and shaped garden beds. Walkergate House, however, has elaborate iron fences and railings, thanks to William Crosskill who lived there from 1855. Crosskill was an industrial entrepreneur (and Beverley mayor for a time) who made his fortune

On the right, Walkergate leads away from Toll Gavel towards Walkergate House.

The three-storey red-brick house is a Grade II listed building.

when he fathered mechanised farming in East Yorkshire. Trained as a whitesmith (tinsmith), he founded a whitesmith, brassfounder and ironfounder business and employed up to 800 people. His workshops created iron gates, railings, and lamp posts. Crosskill also designed agricultural machinery and invented several implements such as the 'clod-crusher'. He received medals and awards for his innovation, and was known around the world for his Emigrant's Implement Box for farmers in places like Canada and New Zealand. The kit was said to contain the farming tools needed to establish a new farm. His firm also manufactured military munitions and carts during the Crimean War. His industry contributed to Beverley being known for a time as the workshop of the world.

In 1924, the house became a home for gentlewomen in need of a home, thanks to a donation from Alexander Boyd. In 1944, the house was requisitioned, presumably because of the war, and the inmates paid to be rehoused.

Walkergate House now serves as the Register Office for marriages, births and deaths in Beverley. There are two ornately decorated ceremony rooms, which have been renovated in their original style with stucco panelling, and the gardens are available for wedding photographs.

27. The Beaver (Nos 10 and 12 North Bar Within)

The Beaver is situated in the Georgian Quarter of Beverley, in North Bar Within. Similarly to the Rose and Crown, it was refronted in mock half-timbering in the 1930s. It was originally built as the Wheatsheaf in 1790, and became the George in 1853. By 1900 it was called The Beaver.

Right and below: The Beaver. Modern lighting and a television has been installed to meet modern demands in this ancient building. (Thank you to the Beaver's managers, Nathan Hoggard and Liam Rogerson, for photo permissions)

The Grade II listed building is a narrow, three-storey, white painted stucco on brick lower level, and the deep building originally consisted of two separate structures, one behind the other. Small stables may once have been attached to the pub at the rear. The entrance and ground-floor shop window are encased in wooden moulded cornices. The timbering is thinner and more curved than most other Tudor-style buildings in Beverley, and the overall aspect is reminiscent of Tudor buildings in London.

Wheatsheaf Lane flanks The Beaver on the east side. It's a thin alley that has been unofficially called Suggitt's Lane in memory of John Suggitt, who held the pub in the early nineteenth century. Three storeys up, unusual artwork hangs over Suggitt's alley between The Beaver and the next building. The copper hanging is part of the Beverley Town Trail, and depicts a leather tunic. Beverley's jerkin makers worked in this area in medieval times and sold their goods on the edge of Wheatsheaf Lane before moving to the nearby Saturday Market.

28. Nos 4-6-8 North Bar Without (set of three connected buildings)

Near the North Bar, a set of three adjoined houses draws attention for their ornate designs and playful decorations. Renowned woodcarver and two-time mayor James Elwell remodelled the houses in 1890 and gave them a lavish appearance. Colourful heraldic shields, carved figures and mottoes, bracket figures, stained glass and even cartoon scenes decorate the houses.

The building was further decorated by adding half-timbering to the upper floors and stone rustication to the brick on the ground floor. The buildings are three storeys and overhang the pavement in many places. An elaborate polygonal tourelle crowns the corner of the houses, giving a fairytale aspect to the whole.

It's not often that in the description of a Grade II listing building mythical beasts are mentioned, but in these late eighteenth-century houses there is that and much more – Disraeli's *Political Cheap Jack* is even mentioned. James Elwell had a wood-carving business with his son (James E. Elwell and Son, Wood Carvers of North Bar Without), as can be seen in receipts held at the National Archives dated 1884. It is possible that Elwell used these buildings to train his son as a woodcarver. His son, Frederick William Elwell, preferred painting to the trade his father taught him, and later became a famous painter. His works are on display at the Treasure House and in the Guildhall, and in 1938 he was granted full membership of the Royal Academy.

James Elwell's more famous woodcarvings include the organ screen carvings in the minster. He created extensive carvings in churches throughout the country.

Although the buildings now house restaurants on the ground floor, they are like playful museums from the street.

Above: Nos 4-6-8 North Bar Without.

Right: The red devil on the turret is one of many whimsical figures on these buildings.

29. Beverley Golf Club, Anti-Mill, Westwood

Along with at least four other mills on the Westwood, the Anti-Mill once functioned as a windmill on the hilly pastures. The Anti-Mill was also known as the Union Mill. It was built between 1799 and 1802 by a newly formed Cooperative Society. By 1803, it functioned as a Cooperative to compete with expensive flour milled by other privately owned mills. It was badly and seemingly fraudulently managed, and the Cooperative ceased using the mill near the middle of the nineteenth century. J. Thirsk of Beverlac Flour then rented the mill until it closed in 1897.

The mill was partially dismantled, leaving only a truncated stump of the former mill. It is a Grade II listed building made of tarred brick. It is three storeys tall and has a crenellated top. The Beverley Golf Club was formed in 1889, and was the first golf club in the East Riding. The golf club on the Westwood made its home in the mill in 1906. The golf course works with particular rules due to its location. When a ball lands in animal excrement or hoof indentations, the player can pick up the ball and drop it over their shoulder rather than hit it in its place, and the player doesn't lose a shot. The golf club pays rent to the pasture masters to compensate for the lost grazing surface.

The truncated tower is the main feature of the course's clubhouse.

Above: From the golf course, Beverley's Minster and St Mary's Church can be seen in the distance.

Below: Some of the more modern brick portions of the clubhouse contrast with the old tarred mill tower.

Many of the buildings in Beverley, including the Anti-Mill, are built of brick. Under the Westwood Pastures, there is a layer of clay, and a layer of chalk below that. Both of these materials have been exploited on the Westwood since the fourteenth century for use in foundations, lime mortar, fertiliser and brick making. Although the last kiln was demolished in 1818, the traces of old limekiln pits can still be seen in parts of the golf course.

Other buildings have been erected around the Anti-Mill as part of the golf club, but the old mill still towers over the golf course and gives it a distinctive look.

30. Beverley Beck Lock and Keeper's Cottage (end of Waterside Road)

When the Beverley and Barmston Drain was built in 1798, the River Hull and the Beverley Beck's levels lowered. To keep the beck navigable, a lock had to be constructed on it. This was built in 1803 and designed by William Chapman, as well as a lock-keeper's cottage. The lock allowed for keels of slightly more than 64 feet long and 17 feet wide. A pump house was built next to the keeper's cottage in 1905, with a steam boiler engine (and 6-inch pump) that could pump water into the beck when the water level was too low. The pump was replaced by a larger cold starting crude oil engine and 12-inch pump in 1935.

An aqueduct was built in the same time as the lock, to float the beck over the quiet waters of the Beverley and Barmston Drain. To this day, boats the

The closed lock and the lock-keeper's cottage in the background.

Above and right: The mostly obsolete lock-keeper's cottage still stands guard by the Beck's lock.

size of houses glide over the bridge-like structure with surreal ease. The bridge and aqueduct are a Grade II listed structure made of red brick with three segmental arches.

The lock helped the beck to collect less silt and sludge brought by the tides, but the water became more stagnant, causing some health concerns. Pumping water into the beck helped alleviate this problem.

The lock-keeper wound the handles of the gates when boats needed to pass, and managed the levels of the beck. The daughter of the lock-keeper, Betsy Hoggard, saved two people from drowning in the beck in 1916. The lock was rebuilt in 1958, but commercial use all but ended by 1987. Barges had grown too large to enter the beck. The lock house was no longer used. After a major renovation of the lock gates and pumping engine in 2007, aimed to turn the area into a leisure district, sensors detect water levels and pumps automatically bring water from the River Hull when needed. Leisure boats and the old Hodson's barge *Syntan* float on the beck.

31. County House of Corrections (Nos 5–13 Norfolk Street)

To replace the old facility next to the Guildhall, the County House of Corrections was built in 1810. The prison complex consisted of three blocks of houses on Norfolk Street, conveniently located behind the Sessions House, which was built at roughly the same time. The prison kept up to 121 prisoners at once (including children), although the initial complex had been built with twenty-two cells.

The main building was the turnkey, or gaoler's house, and was octagonal in shape so that the guard could watch the facility from all angles. In another block (Nos 5 and 7), a tortuous treadmill was kept for the prisoners' hard labour punishment. The treadmill was a simmon: as the prisoners used the treadmill, it pounded bricks for use as pigmentation in mortar, or whiting from chalk rocks. The treadmill looked like a wide staircase that had screened stalls for several

Etchings on the window of one of the old cells can still be seen. (Thank you to Emma Curtis for her kindness and photo permissions)

Right: The octagonal house in the centre of the photo used to be the turnkey's house.

Below: Brickwork and markings against a wall show where the dreaded treadmill used to be.

prisoners to work at once. The treadmill was made of a massive cylinder with outer steps. The work was described by the prisoners as loud and nauseating. A sentence might include 12,000 steps on the treadmill, for example. The third building was where the men's cells were. They were given uniforms and bathed when they arrived. The prisoners were mostly kept apart and fed plain food.

The East Riding Constabulary used part of the House of Correction as a police station, and the buildings closest to the Sessions House were kept as a police station from 1968 onwards.

In 1878 the prison was closed under the New Prisons Act, and some of the buildings were demolished. The other buildings were converted into houses by architects Whitton in 1880. The turnkey house was used as a convent for a few years before also being converted to housing.

Etchings and graffiti made by former prisoners on the walls and windows remain in some of the rooms as souvenirs of the building's past.

32. The Sessions House (New Walk)

Quarter sessions were held in the Beverley Guildhall from around 1703 until 1810, when the county courts were moved to the newly built Sessions House. The construction took place between 1804 and 1814, but was functional by at least 1811. The Grade II* listed building was purpose built as a courthouse and designed by Charles Watson and J. P. Pritchett from York. The adjacent East Riding House of Correction was built at the same time.

Felons of all types, except murderers, were tried in petty or quarter sessions. The mayor, or two other justices, presided over the court and judged the criminals.

In the Sessions House, Sarah Ann Sharpe, a nineteen-year-old servant, was convicted of thieving in 1837. She was sent to Australia by boat where she was to carry out her sentence. Murderers were generally tried in York. Although Beverley was generally more peaceful than other towns in Yorkshire, an increase in robberies in the early nineteenth century led to night watchmen being appointed, along with increased street lighting.

The Greek Ionic tetrastyle stone portico is reminiscent of the Guildhall, which the Sessions House was built to replace. The Sessions House's exterior is more ornate than the Guildhall though. Along with the four massive columns, limestone dressings and pale brick make the building stand out in a primarily residential area. Similar to the Guildhall, a triangular pediment surmounts the columns, but a statue of the figure of Justice adorns its top. Arched windows, carved royal arms and a slate roof add to the grandeur of the building.

The Sessions House has now been converted into a luxurious health spa. The treatment rooms and hair salon have been integrated into the original courthouse through a careful restoration. The contemporary style contrasts pleasingly with the original features.

Above left: The Sessions House.

Above right: The internal decorations come across as luxury mid-twentieth-century modern.

Below: The elegant spiral staircase is central to the interior space. (Thank you to Georgina Parkinson for permission to publish interior photos, and for kindly showing Phil Dearden around the building)

33. Gateway to Beverley Gasworks (Mill View Court)

In 1808, efforts to improve towns led to Beverley and many other places around Britain establishing more effective and regulated street lights. The Lighting and Watching Committee led this effort. At first, the lights were cotton wicks floating in oil, but gas was introduced within two decades. Gas light was introduced in Beverley in 1824 when an Act was passed to allow commissioners to lay pipes and purchase gasworks. Engineer and entrepreneur John Malam of Rochdale entered into a contract with Beverley for 150 street lights, and he built the gasworks near the head of the beck.

The gas was made from carbonisation or gasification of coal, which could be imported on the waterway. The gasworks generated up to 35,000 cubic feet of gas a day.

An archway marked the entrance to the gasworks. Although the carbonisation and gas holding facilities have been demolished to make way for housing, the archway still stands.

St Mary's Church was the first to be lit by gas, and the Sun Inn was the first public house to use gas lighting. The White Horse (Nellie's) is still lit by gas.

Horses and a cart outside the gasworks around 1910. (East Riding Archives)

Above: The imposing entry to the former site of the gasworks is a 22-foot-wide and 25-foot-high Greek Revival gateway, built in a classical style from sandstone.

Right: Dark marks on the archway speak of the site's coal and gas history.

Private homes paid for their connections to the mains if they could afford the luxury. Safety increased from well-lit streets. Gas also cost considerably less than candles, sperm whale oil or rapeseed oil, which would have been used for lighting before gas was available.

The gasworks were acquired by the Improvement Commissioners in 1828, then the Corporation in 1872, and the Eastern Gas Board in 1948 because of nationalisation. Seven watchmen looked after 191 lamps for around half the year (lamps weren't lit in the summer). The watchmen climbed a ladder and lit the lamps with an oil lamp. By 1934, lamplighters were redundant because electricity took over from street gas lighting. The gasworks closed in 1951 when North Sea Gas took over. Gas was no longer mainly made from coal carbonisation in Britain by the 1960s as great quantities of natural gas had been found in the North Sea.

34. Woolpack Inn, No. 37 Westwood Road

The Beerhouse Act of 1830 liberalised British regulations with regard to brewing and selling beer. This led to many new alehouses opening. Shortly after this Act was passed, two cottages, built in 1825 and 1826, were brought together to form a new alehouse, the Boy and Barrel Pub on Westwood Road in 1831. Within a decade, the pub was renamed the Woolpack Inn. It brewed its own ale and had small stables available as well.

For some of its existence, the Woolpack has had a hanging sign depicting travelling merchants and horses laden with wool packs.

The pub sits snugly in a Victorian residential street near the Westwood, and is a Grade II listed building. The Woolpack public house, as the heritage listing labels it, is a white-painted, brick, two-storey building with pantile roof and chimney stacks at the gable ends. By looking at the façade, it's possible to see how two very small cottages formed the current building, yet the Woolpack Inn is one of the smaller buildings presented in this book. The construction materials are simple and remain much as they were built, with wooden window and door frames. A narrow fanlight window brings light into the pub above the door, as well as two windows on the street side of the building.

Like most pubs, it changed hands many times over the decades. By 1889, Cooper and Close purchased the Woolpack from Richard Harrington. The pub had evidently grown as it had a granary and other buildings belonging to it, as well as the stables and the brewery. The Hull Brewery were the owners in the early twentieth century. Despite the different ownerships, the Woolpack remains mostly unchanged, especially in its exterior appearance.

Recently purchased by Marston's, the pub keeps its cozy atmosphere with an open fire and continues to serve a mostly local clientele. Quiz nights and home-style food make the Woolpack a special hidden gem worth finding.

Above: The Woolpack Inn.

Below left: At certain times of the evening, sunlight streams down Westwood Road like gold, and the Woolpack is edged with dreamy light.

35. Memorial Hall (Nos 73–75 Lairgate)

The St John's Chapel of Ease on Lairgate was built in 1840 and consecrated in 1841. The building originally had an undivided nave and sanctuary. The site was donated by Jane Walker. The chapel of ease was initially led by one of the minster's assistant curates. There were two services each Sunday in 1851. It was considered to be a fashionable and comfortable alternative to the minster, which, unlike this building, was not heated. This chapel was also often preferred to St Mary's, which was damp at the time but has since been restored. As the minster and St Mary's Church increased in comfort thanks to improvements, St John's Chapel of Ease became less useful and closed in 1939.

By 1950 it was in poor state and unused. It may have narrowly avoided demolition and was reopened as the Beverley War Memorial Hall in 1959. Prior to its construction, the site was part of Lairgate Hall's park-like gardens.

The chapel was designed by architect H. F. Lockwood from Hull. It is made of grey brick and stone dressings. Much of the construction materials are recycled from the Methodist chapel in Landress Lane, which was demolished in 1837.

The hall is a memorial to Second World War soldiers. It was opened in September of 1959 with the help of public donations, Ministry of Education grants and a £3,000 loan from the Beverley Corporation. The hall is intended for public use and is rented for a fee. Dances, conferences, recreational classes, clubs and even film projections have taken place in the Memorial Hall. The hall is a charity run by a board of trustees, and was recently renovated with the help of the East Riding of Yorkshire Council. The interior was modernised, and the exterior was given a new roof and some of the brickwork was repaired. Improved heating and insulating, as well as disabled access were also part of the recent renovation.

Memorial Hall.

36. Beverley Railway Station

The North Eastern Railway, known at the time as the York and North Midland Railway, linked Beverley to Hull in 1846. The railway's arrival in Beverley changed the town significantly. It meant that the Beverley Beck was no longer the easiest way to access Hull. Where some businesses suffered losses because of the advent of the railway, many others benefited from it.

The railway station is a Grade II listed building, and was designed by G. T. Andrews. It's a single-storey brick building with slate roof and a glazed canopy with iron brackets over the tracks.

The railway station was built on the former site of a Knights Hospitaller preceptory. The Knights Hospitaller were a crusader military order. The site was founded in the early thirteenth century. A moat and gateway enclosed several buildings, a church and a burial ground. When the site was closed in 1540 because of the Dissolution of the Monasteries, it was the richest of its kind in Britain. There were seventy-six such sites around England between the twelfth and the sixteenth centuries. They were used as training facilities for the knights, and to raise money for various causes, such as the crusades to Jerusalem and defending Rhodes from the Turks. This particular site operated as a hospital. The area is a Scheduled Monument, but the remains were buried during the railway and station construction.

The signal box and railway cottage, along with the station building, are good examples of a mid-Victorian-era railway group.

Above and below: Beverley station.

The Corporation of Beverley purchased the site in 1576. The area was later used as a leper burial ground, and eventually as a plant nursery before the railway station was built.

The Beverley railway station included a licensed 'railway refreshment room' or bar soon after it opened, as well as ticket offices. Beverley became a junction station in 1865 when Market Weighton (and York) was linked, but the York to Beverley line closed in 1965. The station continues to link Beverley to Hull as well as Bridlington.

The station is a short walk from the town centre, and a clock tower watches guard over the parking at the front of the building.

37. Grovehill Shipyard, now Acorn Industrial Estate (Riverview Road)

Wooden boatbuilding and shipwrights existed along the Beverley Beck and the nearby River Hull since the twelfth or thirteenth century, but the activity is formally recorded from the nineteenth century. A dry dock was constructed in 1858, and a slipway to the river was soon added. The first iron ships were launched in 1882 by the Scarrs near the beck and the River Hull, in an area called Grovehill.

Beverley had a great boatbuilding reputation for many years, making minesweepers, trawlers, ice breakers and fishing vessels of high quality. In 1902, Cochrane, Hamilton and Cooper employed 400 men. Hull and Grimsby's fishing industry, as well as fishing in the Icelandic seas and further afield brought many new ship orders. A total of 650 people were employed at the shipyard in 1954, and the site was once the world's biggest trawler maker. Development of onboard fish-processing machinery was also a business in the area.

Children who grew up in the region in the 1950s recall hundreds of men biking in and out at the start and end of their work days. It was safer to stay off Grovehill Road at those times. Crowds usually gathered for boat launches. The unusual and curious sideway or broadside launching created a great splash (see page XX). The shipwrights launched the new boats with united precision by knocking the timbers away with hammers.

Although the boatbuilders changed over the decades (Scarrs, Vulcan Iron Works, Cochrane, Hamilton and Cooper, Cook, Welton and Gemmell Ltd, CD Holmes, the Drypool group of shipyards, Whitby Shipbuilders/Phoenix Shipbuilders), the shipbuilding yard on Grovehill finally ended in 1977 when competition from foreign shipbuilders and demand for larger ships that couldn't be floated down the River Hull made business difficult.

The site closed in 1977 and the Beverley Borough Council developed the area into the Acorn Industrial Estate. Some small boatbuilding work continued in the area, which now has newer and mostly metal warehouses and a few brick buildings.

Above: A sideways launch of the *Vera* in 1907. (East Riding Archives)

Below: Grovehill shipyard, 1950. (East Riding Archives)

Modern-day Acorn Industrial Estate.

38. Westwood Park Homes, formerly Beverley Union Workhouse and Westwood Hospital (Woodlands)

The Westwood Hospital was built as a workhouse for the poor on the edge of the Westwood pastures. The Beverley Union Workhouse was built in 1860 in Elizabethan design, of red brick and stone dressings. The Grade II listed building has a Welsh slate roof. The central block of the main building is two storeys and has a moulded gable with a stone finial and bell. There are two wings at right angles of the central block of the building. The building was designed by architects Atkinson of York and cost £5,500. The main building was drawn out in the shape of the letter 'H', allowing the women's yards to be separated from the men's.

Prior to the Union Workhouse's construction, the Minster Moorgate Workhouse stood near the minster from 1727 until 1861. Workhouses were born in the seventeenth century under Elizabeth I's reign. Parishes were responsible for caring for destitute people's basic needs in return for work. The workhouses generally had difficult conditions and strict rules meant to deter all but the neediest. Children living in the workhouses went to school each day in the community.

At the entrance to the grounds, an arch forms a gateway over the access road. The impressive red-brick and stone dressing structure was also built in the mid-nineteenth century, and is equally a Grade II listed building. The gable over the road has a circular window with a keystone as well as a keystone to the

Left: Westwood Park Homes.

Below: Nurses care for children in the 1940s.

moulded archway, and scrolls at the end of the gable. The arch's interior is barrel vaulted and lined with wood (see page 74). Though some initially criticised the design, it is in keeping with the other buildings on the grounds.

The workhouse could accommodate 189 inmates. It was renamed the Public Assistance Institution, and in 1939 became a hospital for the Second World War. The occupants were rehoused in other facilities. After the war, it became the Westwood Hospital. As needs for more modern facilities arose, the hospital became obsolete and a new community hospital on Swinemoor Lane replaced it in 2011. The Westwood site was recently converted into luxurious apartments. The last baby was born at the Beverley Westwood Hospital in 1997.

39. The Former Corn Exchange, now Brown's (Saturday Market)

Corn was traded on this slightly raised area of Saturday Market in Beverley since before the seventeenth century. The area was known as Corn Hill. In 1753, Samuel Smith designed a building for the butchers' shambles and the corn merchants to trade in. By 1886, the building was demolished and replaced with a new building by architect Samuel Musgrave.

The corn merchants shared the building with the butter market, as well as swimming baths. The baths were literally slipper bath tubs initially, and locals with no bathrooms were likely to use them. The baths section of the building was eventually improved to a small pool, sarcastically referred to as the 'Beverley Puddle' because it was an unusually small pool. It was closed in 1973, in favour of larger swimming pools in nearby towns.

A cinema, the Beverley Picture Playhouse, also shared the building from 1911 to 2003. The Band of Hope Union criticised the cinema, which was one of the

Below left and right: The baths in the Old Corn Exchange were briefly closed during the Second World War and served as decontamination for gas attacks.

first in the country, as they believed crime would increase as a result of watching murder and sex on the projected films.

The Former Corn Exchange is a Grade II listed building made of red brick and terracotta with a Welsh slate roof. It has a gabled centre, not unlike the original 1753 building. The façade has an air of grandeur with scrolls, pilasters and rosettes, yet the interior has been tastefully painted in white giving an airy feeling to the building. Corn ceased to be sold in the Corn Exchange in 1947, and Brown's department store occupies the premises.

40. St John's Ambulance Brigade Headquarters, former Scotch Baptist Chapel (Morton Lane)

The Beverley St John's Ambulance Brigade Headquarters occupy the former Scotch Baptist Chapel on Morton Lane. The building was erected in 1888. Although this nineteenth-century brick building is not listed, its Flemish-looking curved gables makes the red-and-brown brick building worthy of note.

The Scotch Baptist Chapel appears to have been a daughter church to the Hull Church in the eighteenth century. The Scotch Baptists met in a meeting house on Walkergate before moving to newly built church on Morton and Wilbert Lane at the end of the nineteenth century. The construction cost £800 and had room for 200 seats, as well as a schoolroom. Scotch Baptists were different primarily

Opposite and right: This Flemish-influenced building housed a Scottish church in a striking building that is infrequently noticed among the countless other beautiful and intriguing local buildings.

from other Baptists by their belief that a trained and paid ministry was not necessary. The building housed the church until at least 1927, but divisions between more and less strict Biblical interpretations may have contributed to this edifice's change of use.

Although it had a relatively brief life as a traditional church, the New Harvest Church now shares the building with the St John's Beverley Brigade Ambulance Headquarters.

41. Urinal to the Sessions House (New Walk)

A urinal may seem like an unlikely entry in this book, but without these kinds of public facilities, filth and disease would have been far more rampant. The rapid spread of typhoid and the plague at times in British history made the need for sewers and public toilet facilities key in maintaining a healthy society. The smell and inconvenience of the lack of such facilities also created unpleasant and sometimes embarrassing situations. Beverley had several of these urinals installed around the town for public use. The first one installed in Beverley was by the side of the Corn Exchange, after people complained that cattlemen were using the street as a toilet.

The urinal to the Sessions House is a green cast-iron urinal that is one of 467 listed structures in Beverley. The Grade II listed structure was made in

Above and left: The Victorian cast-iron urinal can be seen in the Sessions Spa's front garden by night or day – a spotlight illuminates it at night.

Birmingham in the late nineteenth century and is oblong in shape. Panels with stars and geometrical borders decorate the urinal, and a middle section with a Greek decoration and a cornice suits the Sessions House to which it belongs. It's considered to be a rare surviving urinal from its time, and is in good condition.

For many years the urinal disappeared in the bushes of the gardens, but has recently been freed from the encroaching vegetation. It stands proudly in the spa's front garden – a memory of Beverley's civilised history.

42. Cross Street County Hall

Cross Street County Hall consists of expansive buildings in the centre of Beverley. When given independent county status, the East Riding County Council had a three-storey building designed by Smith and Brodrick and erected in Cross Street in 1891. The builders were Ives & Co. of Bradford, and the construction cost was £7,300. The hall was opened in January 1892.

It is built in a Flemish Renaissance style with red-brick and Ancaster stone detailing, and still has the original and mostly unaltered semicircular council chamber. Some of its wooden furniture was carved by twice-mayor James Elwell (Fred Elwell's father). Oak fittings, panelled walls and carved fireplaces are

examples of the elaborate character of the interiors. The Grade II listed building has a slate roof with lead hips and ridges, and iron gutters. A decorated stone entrance with attached columns, two-storey canted bays, and shaped gables add to this elegant hall.

This building was made famous by Anthony Trollope's novel *Ralph the Heir*. In the novel, Trollope depicts his own experience as he stood as a Liberal candidate in Beverley in 1868, but because of corruption he was not elected. The novel paints an unfavourable and thinly disguised picture of Beverley politics in the nineteenth century.

Part of an octagonal stone Gothic turret from St Mary's Church sits on a stone base in a border next to the car park. It is a Grade II listed structure and dated to the fifteenth century.

The original design provided the possibility of extending the building in the future. Modern extensions to the original hall, as well as repurposing of nearby buildings, have led to the County Hall consisting of extensive buildings. The south-east wing was built in 1831 as a gentlemen's club with a Greek Doric entrance and a painted stucco façade. It was later included into the County Hall buildings. The building sits on the site of the former Mechanics' Institute building. The former Register Office is also part of the Cross Street County Hall buildings. The county records are held in a strongroom on the ground floor.

Cross Street County Hall.

Above left: When the light catches the thousands of small glass panes, the building can feel as though it glimmers.

Above right: The East Riding Theatre can be seen in the background, not far from the County Hall.

43. Toll Gavel Church: Toll Gavel

The Methodists' history in Beverley is not as sedentary as some of the other local religious groups. The Methodists first established themselves in the town around 1750. They used several different locations and buildings for services throughout the first 150 years of their existence in Beverley. There were some significant divergences between their different interpretations of their religion, and several churches were erected as a result. Toll Gavel Church was built in 1892 on the burial ground of Walkergate Chapel, and was extended in 1901. It was a building in an Italian style by architects Morley and Woodhouse of Bradford. The front of the building had three doors under an open portico, but has since been closed in. The Italian stone front contrasts with the rest of the building, which is in red brick. There's room for nearly 1,000 people. The construction cost £4,000, and the majority of the money was raised by the Young Men's Association.

The nearby Walkergate Chapel was demolished and a Sunday school linked with the Toll Gavel Church was built instead in 1903.

Above and right: Toll Gavel Church.

In 1926 and 1955, this church united with other local churches and became the Toll Gavel United Church. A white-framed glass conservatory and red metal handrails have been added to the front of the church in 1990 during a larger refurbishment project, drawing away from the stonework's balanced aspect, but likely adding to the entrance's comfort and utility. The building is now a busy church in the centre of town, and functions as a partnership between the United Reformed Church and the Methodist Church. The church is also used as a venue for concerts. It is set back from Toll Gavel, and two gate piers mark the break in the street.

44. Roman Catholic Church of St John of Beverley, North Bar Without

The Roman Catholic church in Beverley is a playful-looking Victorian Gothic (or Gothic Revival) red-brick building with a turret placed asymmetrically on the left side of the building. Finely cut stone dressings decorate the windows and doors. The church was designed in 1897 by architects Smith, Brodrick and Lowther, and built by G. Pape.

Near the site of the church, well before its construction, was a pool of water used for ducking. A cuckstool, or ducking stool, was apparently used there from 1379 for around four centuries. People (mostly women) who had committed a petty crime were attached to the stool and submerged several times.

The Roman Catholic Church of St John of Beverley is a Grade II listed building, immediately to the right of the mock Tudor-style Rose and Crown. The contrast between these two buildings highlights each in a pleasing way. The Welsh slate roof is supported by a timber purlin roof, visible from the relatively plain interior.

Above: Finely cut stone dressings decorate the flat-arched traceried windows.

Left: Roman Catholic Church of St John of Beverley.

15. Grammar School (Queensgate)

Beverley Grammar School is the oldest state school in England. Founded in the eighth century on the minster grounds, it was first a college of priests. It was still linked with the minster at the Dissolution of the Monasteries in the sixteenth century. In the seventeenth century, the Beverley Grammar School was considered to be one of the best in the country, and many of the students went on to Cambridge University. Beverley's intellectual and economic climate was said to be raised by the school's influence.

The school has moved to several locations through its twelve centuries of existence. After occupying three buildings on the grounds adjacent to the minster, the school was briefly housed in the Guildhall in 1736, and also moved to a temporary location on Grayburn Lane in 1889.

However, there was a less glorious time in 1865 when the school was said to be unclean, out of repair, and attended by only fifteen pupils. In 1889 the school was reestablished with increased financial assistance and accommodated ninety students.

In 1902, a new school was built on expansive grounds on the edge of the Westwood. At first built for seventy students, it was expanded to accommodate 100 students during the First World War. A sports pavilion and other temporary huts were built in the early twentieth century, and a larger brick building was

The grammar school's sports pavilion.

Above and left: The Grammar School and extensive grounds. (Thank you to Beverley Grammar School for photo permissions)

erected in 1936. The 1902 building became the manual labour workshop, and many retirees in Beverley remember building canoes or working on other projects in this building. Other extensions and new additions have grown on the site over the course of the twentieth century and into the twenty-first century as the school continues to expand. A total of 800 pupils now attend the school.

46. Public Library (Champney Road)

Although limited book lending was available in Beverley from 1740 onwards, the public library was only built in 1905 thanks to a donation by John Champney. The original portion of the red-brick building was designed by architect John Cash, and first extended in 1928 in a similar style by architect Herbert Cash (son of John Cash). The Edwardian (and Jacobethan-style) building is listed as Grade II, and is considered to demonstrate expert building craftsmanship with sandstone banding and terracotta dressings. It forms part of a cluster of Grade II listed civic buildings.

The original entrance showcases a tiled floor of grey and white geometric patterns, and barrel-vaulted ceiling. The elegant library's floors are mostly polished herringbone parquet.

Many of the construction details are original, such as the doors and windows of the library.

Above and left: The library's many facets reveal a consistent yet varied building structure.

Champney, who funded the construction, wished for the library to be low maintenance and solidly built, and had the foresight to request that there would be room on the grounds to expand in the future. The library was built according to his wishes, and he supervised much of the construction's progress. In the first year of its existence, the library consisted of a newsroom and a lending library. It was well received, and the offering was quickly expanded. The art gallery was built in 1910 to the rear of the library, and holds many of the paintings of the famous local artist Frederick Elwell.

The books were accessible to everyone by 1920, when the library ceased to operate as a closed-access system where only certain people had free access and others had to pay for the service. The library was extended again in 1971 when offices, a record room and a junior library were added. The library and attached art gallery have free admission and are now connected to the Treasure House, which was built in 2007.

17. Post Office (Register Square)

When postage stamps were introduced in Britain in 1840, Beverley was serviced by a post office on Toll Gavel. Britain was a global leader in postal services. From the twelfth century onwards, Britain created an innovative system of posting houses where messengers could rest, change horses or pass on messages. The idea of messengers was not new as the Romans had built a network of roads and messenger relay services called the Great North Road. The efficient system was novel, however, and allowed post to travel quickly around the British Empire. The invention of the stamp also allowed the postal system to make profits rather than the previous years' losses as had been the case from the sixteenth century onwards when Charles I covered the excess expenses of the postal service.

The post office was moved from Toll Gavel to Register Square where a new building was inaugurated in 1905. The two-storey red-brick building is purpose built and unpretentious, in contrast to its neighbouring buildings like the Guildhall and the County Hall. Its aim was not beauty, but rather productivity. John Gardham was the first postmaster in the new building, and letters arrived daily (including Saturdays, but not Sundays), twice a day from York and Hull, and once a day from London.

Beverley's busy post office may be moved back to Toll Gavel, but this time into a shared space with a retail partner. The motives for this controversial move are primarily financial, but many locals disapprove.

The postal system's importance continues, although it has changed in recent years. The postal system was crucial to the way of life of Beverley, and more generally Britain, for centuries. Although it wasn't central to the community in the way that the churches would have been for a long time, the postal system was one of the most important lifelines for trade and administration for the town and its people.

Above and left: Post Office.

48. East Riding Theatre, converted Baptist Chapel (No. 10 Lord Roberts Road)

The East Riding Theatre was built as a Baptist church in 1910. It was designed by architect George Pennington of Garside. It had a congregation of 400 people. The Grade II listed church is of red brick and terracotta, and was designed in a the English Free School style, or Free Perpendicular style. It has a concave sided roof with a wooden bellcote, and has a distinctive appearance thanks to a large semicircular traceried window above the projecting stone porch.

It stopped being used as a church in 1964, presumably after the building's size and maintenance outweighed the needs of the diminished congregation. The Baptists from the former Lord Roberts Road Chapel met in the Friends' meeting house in Woodlands from 1964 until 2000, and now meet at Swinemoor Junior School.

The building is now home to the East Riding Theatre (ERT). It was founded by Beverley actor Vincent Regan. The convenient location on Lord Roberts Road

East Riding Theatre.

The large semicircular traceried window retains the theatre's traditional church aspect.

allows for easy access and parking. Renovated in 2014, the theatre seats 195 in the main auditorium. The smaller chapel that was used as a Sunday school and clergy offices has now been transformed into a café. Part of the movie *Dad's Army* was filmed here. The theatre is unfunded and offers quality shows in a stunning setting.

49. The Treasure House (Champney Road)

The Treasure House forms part of a group of much older civic buildings. It's strikingly modern and different from its surroundings, yet isn't out of place. Similar building materials (mostly red brick) have been used, but the contours of the structure are strikingly modern.

Tanning took place on the grounds of the Treasure House in medieval times. When the foundations were dug, archeologists found pits and cattle horns on the site, confirming this theory. Dung and animal brains were used in the pits to soften the hides.

Some of Frederick Elwell's paintings can be seen at the Treasure House. Swords from the Iron Age found in nearby South Cave in 2002 are also on exhibit.

The distinctive Treasure House tower offers a good view of Beverley and the minster.

The East Riding Treasure House was built in 2007 as a multidisciplinary centre for heritage and information services. It's a cultural centre run by the East Riding of Yorkshire Council, and was built adjoining the public library. It holds accessible archives, a research room, local heritage exhibitions, a café and a gift shop. The building has a wealth of culture and history available. Maps, images, charters, digital records and many other mediums preserve around a thousand years of local history in this building.

5c. Former Hodgson's Tannery and Flemingate (Flemingate)

The town of Beverley has had a thriving tanning industry since medieval times, and possibly before. Everything a tanner needed was available nearby. Lime and oak bark were readily available on the Westwood, and water ran through the town. Flemish weavers and dyers gave the name to Flemingate in the eleventh century.

An important tannery in Beverley was Richard Hodgson and Son's Tannery on Flemingate. It was one of the biggest tanneries in Europe in the twentieth century, employing around 1,000 people. A steam engine was installed in 1822, and mechanisation increased production. Vegetable tanning was used at Hodgson's until 1959, when chrome tanning was incorporated into their processes.

Left: Flemingate replaced Hodgson's Tannery.

Below: A worker stretching hide in the 1950s. (East Riding Archives)

Hodgson's maintained a fleet of seventeen barges on the Beverley Beck. Supplies such as coal from the South Yorkshire coalfields and hides from Argentina were floated into the town.

The tanning industry produces offensive smells as hides are turned into leather, and the area around Flemingate was often smelly while the tanning industry was active. Hodgson's was passed from father to son over several generations. A secondary business of gelatine and glue manufacture was created in 1892. Leather was also produced for the military during the First and Second World Wars.

A fire damaged Hodgson's upper leather factory in 1969, but the damage was quickly repaired. The Hodgson's facilities covered 14 acres of land and was the biggest tax payer in Beverley at its peak in 1970. By 1974, industrial crises affected the tannery and it closed.

In the twenty-first century, the Flemish weavers and Hodgson's tanners have disappeared. Hodgson's factory buildings were demolished in 2005 and made way for a 16-acre facility in 2015. Flemingate Beverley is a shopping mall, cinema, hotel, housing development and college campus. The facility has been built in a mostly sympathetic style to local architecture, although the brick buildings are obviously modern. Wykeland Ltd of Hull developed Flemingate.

The end of the tanners, weavers and dyers in Beverley is unfortunate, although likely unavoidable. Hodgson's Tannery was one of the pivotal centres for Beverley's thriving industry and is now just a memory that has been lost to international competition.

Bibliography

Baggs, A. P., L. M. Brown, G. C. F. Forster, I. Hall, R. E. Horrox, G. H. R. Kent, and D. Neave, *The Victoria History of the Counties of England: A History of Yorkshire East Riding*, Volume 6 (London: Oxford University Press, 1989)

beverleyfm.com/history

British History Online (www.british-history.ac.uk)

Cornforth, J. and M. Wright, *New Look at a Northern Town* (Beverley: Country Life, 1971)

Deans, Patricia, *Beverley Through Time* (Amberley Publishing, 2009)

East Riding Archives (eastriding.gov.uk)

Gibson, Paul, *A Toast to the Town: History of Beverley's Public Houses* (Hull: Kingston Press, 1988)

Historic England (historicengland.org.uk)

nosivad.co.uk/beverley-westwood

patrickbaty.co.uk/2013/03/29/market-cross-beverley-east-yorkshire

Peach, Howard, *Curious Tales of Old East Yorkshire* (Cheshire, 2001)

Poulson, George, *Beverlac; or, the Antiquities and History of the Town of Beverley* (London, 1829)

Ryder, P. F., *The Medieval Buildings of Yorkshire* (Ash Grove Book, 1982)

Salter, M., *Medieval Walled Towns* (Folly Publications, Malvern, 2013)

Sheahan, J. J., *The Town of Beverley* (1856)

Sherwood, David, *Complete Streets of Beverley* (Beverley: East Riding of Yorkshire Council, Hutton Press, 2002)

'The Gas Adventure at Beverley' (KOM Golisti, 2001)

The National Archives (discovery.nationalarchives.gov.uk)

Various Guildhall publications

Wright, John, *The Postal History of Beverley*, No. 20 (Nottingham: Yorkshire Postal History Society, 1986)

www.genuki.org.uk/big/eng/YKS/ERY/Beverley/Beverley92

www.gutenberg.org/files/52367/52367-h/52367-h.htm

www.hullcivicsoc.info/pdfs/Heritage%20Open%20Days%202017/BEVERLEY-HOD.pdf

www.localhistories.org/beverley

www.tollgavelchurch.org.uk/history

www.visithullandeastyorkshire.com/beverley/history-and-heritage.aspx

Acknowledgements

Lorna Jane Harvey

Thank you to Judith, Joyce, Billy and Ralph Robson for their stories, Jeanne Franssen for her great help preparing this book, and my family for their patience and help as I composed this work. Thank you to all the people who allowed Phil and I to take photos of these buildings, and gave us their stories and words of encouragement. Thank you to Phil Dearden for his great work, and to Amberley Publishing for their help and trust.

Phil Dearden

Thank you to the people of Beverley for allowing me to enter their businesses and private homes to take photos. Thank you to my wife for being so understanding and patient while I took on this venture. Thank you to my family for all their encouragement, and to Terry Pacey for making me see that I had an eye for photography. Thank you to everyone at Amberley Publishing for all their help, and also the chance to do this. And lastly, but by no means least, to the author Lorna Jane Harvey for spotting my work on Flickr and giving me this truly wonderful opportunity.

About the Authors

Lorna Jane Harvey is a British, Canadian and Swiss writer currently located in New Zealand. She has written or edited several books, including the novel *Jet Black Stones* and the anthology *Somewhere: Women and Girl Migrants*. As her family is from the lovely town of Beverley, she has fond childhood memories of it and thoroughly enjoyed preparing this book.

Phil Dearden is an English amateur photographer currently living in Doncaster, but born and raised in the little West Yorkshire town of Ossett. Being a true-blooded Yorkshire man, he was up for the challenge of doing the photography for this book as it took him away from his normal comfort zone of landscape photography, and has thoroughly enjoyed visiting Beverley and meeting some wonderful people. He has a Flickr page and can be found on his Facebook page 'PDPics'. He is currently working on his own personal website.